THIS BOOK IS DESIGNED FOR ALL THOSE WHO ENJOY THE COMFORT AND THERAPEUTIC VALUE OF COOKING AND COLORING.

THE RECIPES ARE EASY, AND ARE COMBINED WITH COLORING PAGES OF VARIOUS LEVELS OF DIFFICULTY.

GLUTEN FREE RECIPES ARE INCLUDED.

BLANK PAGES HAVE BEEN ADDED FOR NOTES.

ENJOY!!

COOK AND COLOR

CREATE YOUR CUSTOM COLORED

COOK BOOK AND ADD

YOUR OWN

RECIPES

ON THE NOTE PAGES

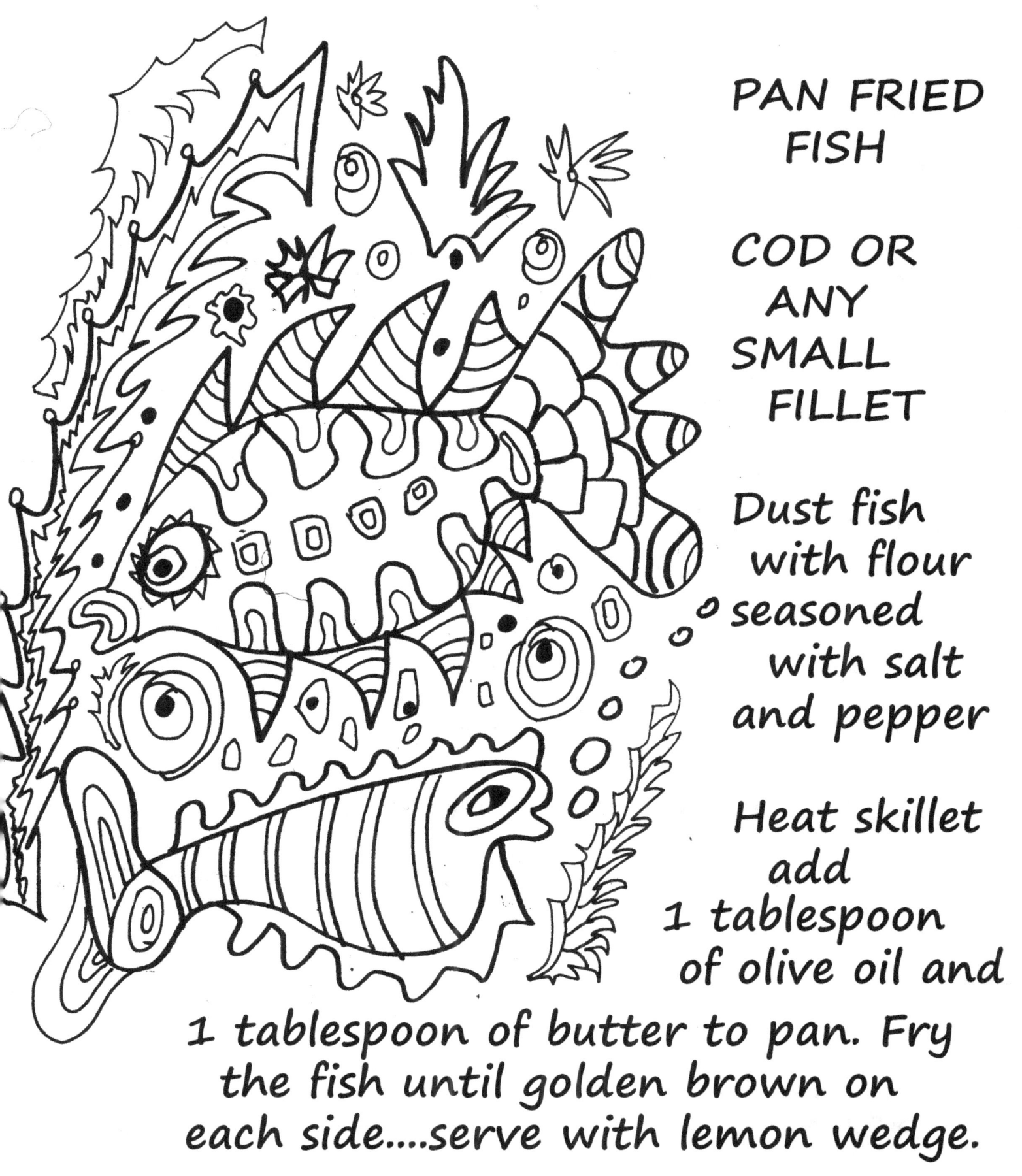

PAN FRIED FISH

COD OR ANY SMALL FILLET

Dust fish with flour seasoned with salt and pepper

Heat skillet add 1 tablespoon of olive oil and 1 tablespoon of butter to pan. Fry the fish until golden brown on each side....serve with lemon wedge.

EASY LEMON CAKE IN A MUG

SPRAY A LARGE MUG WITH OIL.

MIX TOGETHER:

ONE EGG, 4 TBSP. MILK, 3 TBSP. OIL, 2 TBSP. FRESH LEMON JUICE, 4 TBSP. RAW SUGAR, 4 TBSP. WHITE UNBLEACHED FLOUR (OR GLUTEN FREE FLOUR), 1 TEASP. BAKING POWDER.

WHEN WELL BLENDED, MICROWAVE FOR 3 MINUTES AT FULL POWER.

LET COOL AND SLICE.

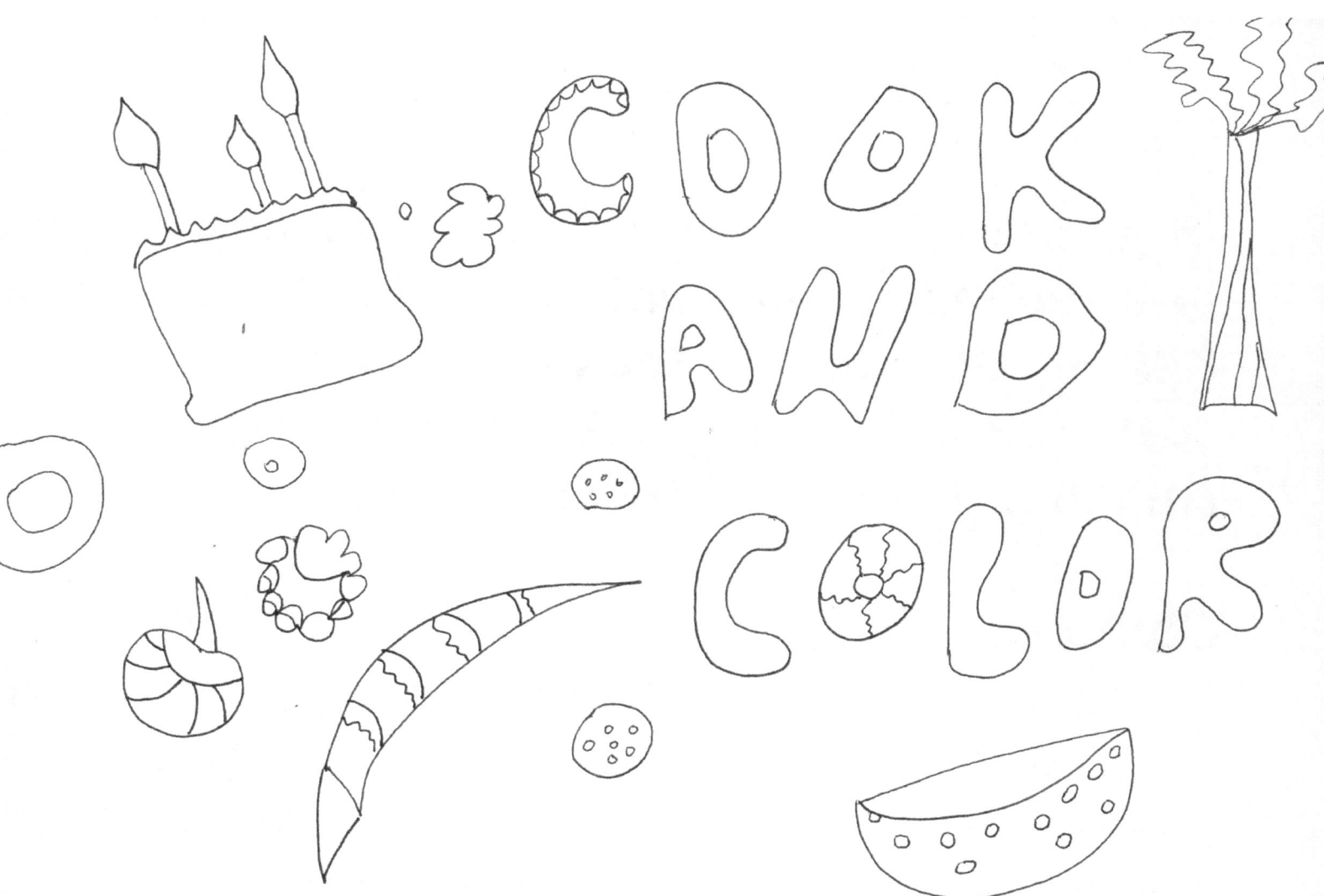

MOM'S NOODLE PUDDING

Cook 1 package of wide noodles in boiling water for 8 minutes. Cover and let sit for 30 min. Drain. In a large bowl add noodles and 1 cup each of sour cream, cottage cheese, cream cheese, raisins. add 3 beaten eggs, 2 tabls. oil and 1 tabls. cin.; add pinch salt. Mix, and add to a greased loaf pan. Bake 375F 50 min. or until golden brown.

EASY SODA BREAD

Ingredients: 3.5 cups flour, half cup sugar, one half teaspoon baking soda, 2 teaspoon baking powder, 1 teaspoon salt, 2 cups yogurt, 2 eggs, 2 tablespoons carraway seeds, 3/4 cup raisons.

Combine all dry ingredients in large bowl. In a small bowl beat eggs and yogurt, and add to dry ingredients. Mix all with a wooden spoon. Batter will be sticky. Dust top with a bit of flour make a shallow x on top; place in a 9" greased loaf pan.

Bake for 50 min. in a preheated oven at 350F degrees. Cool on wire rack for 15 minutes. Enjoy with fresh vegetable soup.

3 MINUTE CHOCOLATE CAKE IN A LARGE MUG

SPRAY A LARGE MUG WITH OIL.

MIX TOGETHER IN A MUG:

4 TBSP. FLOUR, 4 TBSP. SUGAR, 2 TBSP. UNSWEETEND COCOA, 1 EGG, 3TBSP. MILK, 3 TBSP. OIL, DASH OF VANILLA, DASH OF SALT, DASH OFMBAKING POWDER.

SLICE WHEN COOL.

NOTES

ONE MINUTE COOKIE IN A MUG

MIX TOGETHER IN A MUG:

ONE TBSP. MELTED BUTTER

ONE TBSP. WHITE SUGAR

ONE TBSP. BROWN SUGAR

DASH VANILLA

1/4 CUP FLOUR

CHOC CHIPS AND NUTS

ONE EGG YOLK

MIX UNTIL SMOOTH

MICROWAVE 40-60 SECONDS

SALMON SALAD

1 can salmon

2 tbls. mayo

1 tbls. yogurt

celery

green onion

1/2 teas. mustard

Chop celery and onion (about 1/4 cup for both)

Mix all ingredients together until well blended; season to taste with a pinch of salt , pepper paprika......serve on a bed of lettuce.

EASY LEMON CURD

Zest 3 lemons. Put into processor with 1.5 cups of sugar, pulse. Cream 1/4 lb. unsalted butter. Beat in sugar and lemon. Add 4 eggs, 1 at a time, and add one half cup of lemon juice, pinch of salt. Pour the entire mixture into a saucepan and cook over low heat, stirring constantly, until thickened...approx. 10 minutes. Serve hot or cold.

3 MINUTE BANANA BREAD

SPRAY A LARGE MUG WITH OIL

MIX TOGETHER THE FOLLOWING:

3 TBLS. FLOUR, 1 TABLS. SUGAR, 2 TBLS. BROWN SUGAR, DASH SALT, DASH BAKING POWDER, DASH BAKING SODA, 1 EGG, DASH VANILLA, 1 TBLSP. OIL, 1 TBSP. MILK, 1 RIPE AND MASHED BANANA.

POUR INTO MUG AND BAKE 3 MINUTES OR LESS. LET COOL.

GLUTEN FREE BROWNIES

Ingredients:

4 eggs
1 cup cocoa (unsweetened_
3 tbls. oil
2 teas. vanilla
pinch salt

Directions:

Mix all in a bowl. Pour into 8" loaf pan lined with parchment.

Bake in 350 degrees oven for 25 to 30 minutes.

Cool completely before slicing.

NOTES

EASY FRIED/BAKED CHICKEN

One whole chicken, cut up
1/2 cup buttermilk more or less
1/2 cup flour...more or less
salt and pepper to taste

Dip chicken in buttermilk
Add salt and pepper to flour
Dip chicken in flour

Place on oiled baking sheet

Bake at 375 degrees 45 min.

FISH STEW

Boil 4 quarts of water; chop 1 stalk of celery, 1 med. onion, 1 potato and 1 carrot. Cut up 1 lb. of mixed seafood: shrimp, halibut, and any firm fish. Add veggies to water and simmer for 20 min. Add seafood and cook for an additional 10 min. Add parsley at end.

BASIC WHITE SAUCE

2 tbls. butter

2 tbls. flour

1 cup milk

Melt butter, add flour, stir until blended, slowly add milk to flour mixture until smooth.

Serve over hard boiled eggs over toast triangles; or over cooked chicken with peas and carrots; or over chipped beef on toast; or over ham slices on buns.

Add cheese for added flavor. and serve over noodles. Comfort food....easy and delicious!

POTATO PUDDING - KUGEL

PEEL AND GRATE 5 MED. POTATOES, PLACE IN A MED. BOWL.. GRATE AND ADD 1 ONION. ADD 1 EGG AND 1 CUP OF EVAP. MILK. ADD A DASH OF SALT AND PEPPER.

BAKE 375F IN A GREASED LOAF PAN FOR 1 HR

GLUTEN FREE PEANUT BUTTER COOKIES

BEAT TOGETHER:
1 cup peanut butter; 1 cup sugar, 1 beaten egg, 1 teasp. baking powder.

Roll 1 teasp. of dough into a ball. Place on to a cookie sheet. Flatten with a fork.
Bake in a pre heated oven 350f. for 10 minutes or until lightly browned on edges. Let cool for a few minutes. Cool on wire rack for 10 min.

EASY ZUCCHINI PANCAKES

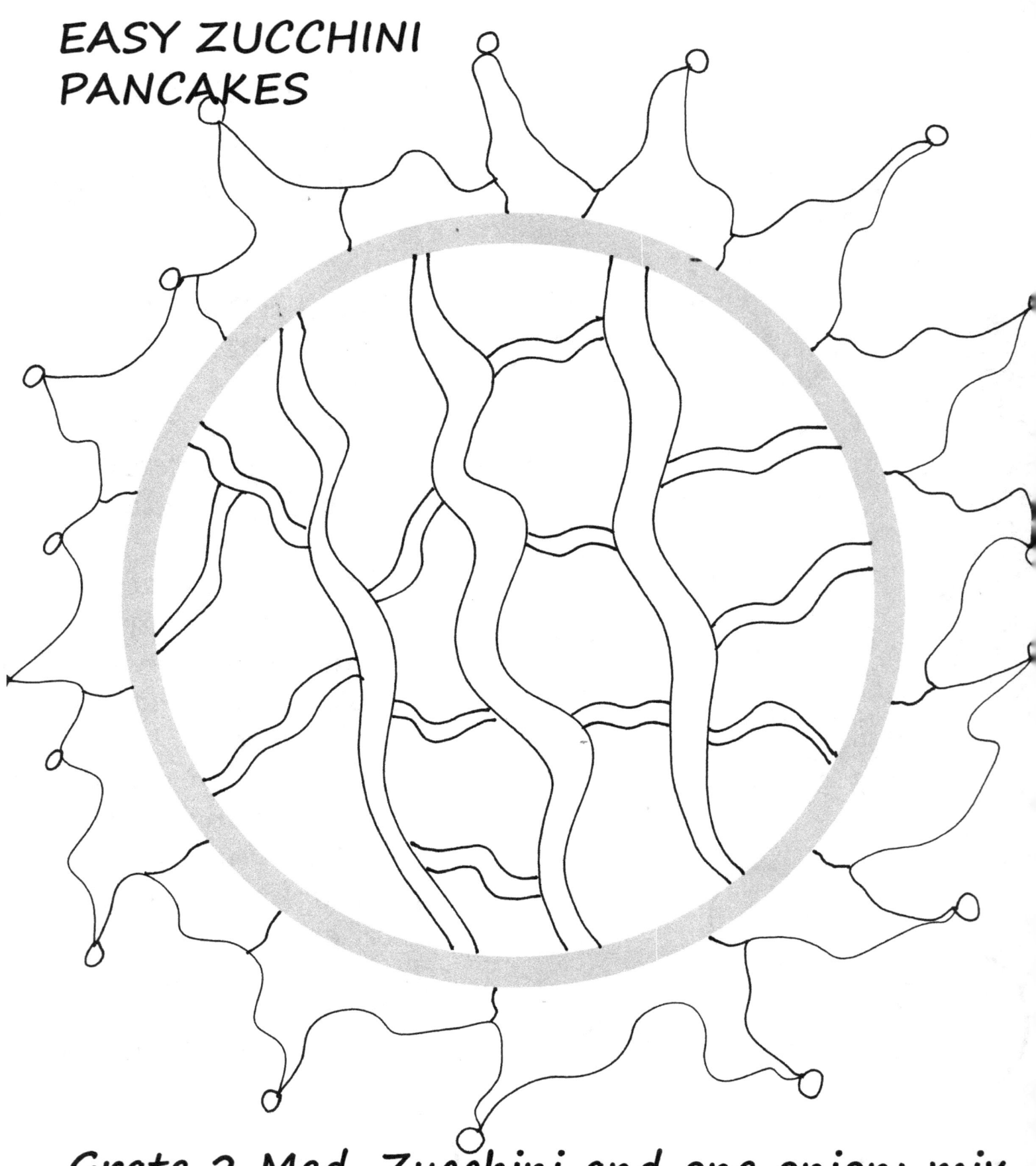

Grate 2 Med. Zucchini and one onion; mix with 2 eggs, 4 tbls. flour, 1 teas. bp, pinch nutmeg, pinch salt and pepper. Spray pan with oil, fry until golden brown.

NOTES

SLOW COOKER CHICKEN CURRY

Chop 1 onion, 1 carrot, 1 potato and add to the bottom of crock pot which has been sprayed with oil. Lightly flour 3 chicken breasts and sprinkle with 2 tbls. garam masale and 1 teas. smoked paprika. Add Cook high for 3 hours.

Add 1 can light coconut milk and cook for an additional 15 minutes. Garnish with cilantro.

NOTES

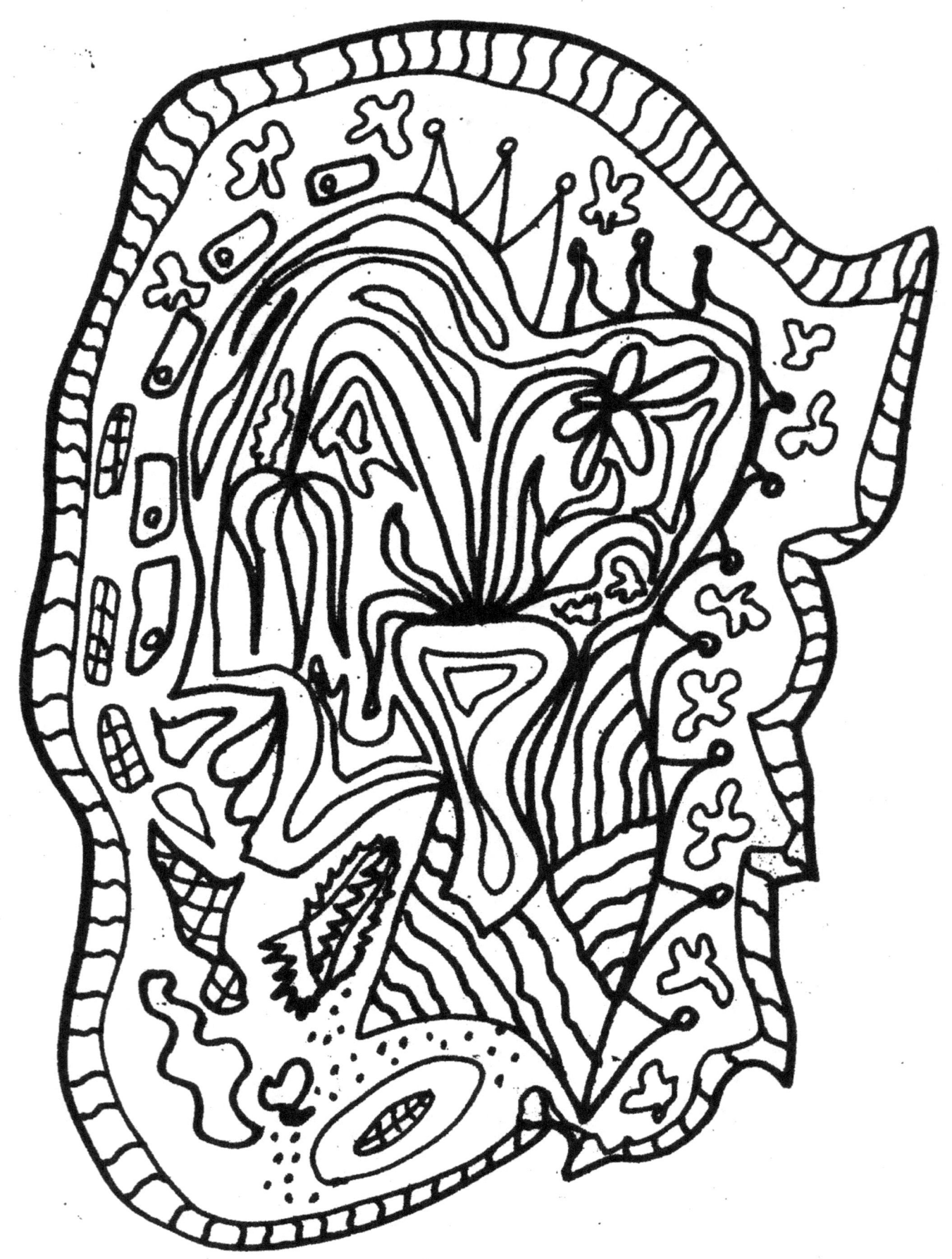

NOTES

NOTES

NOTES

www.ingramcontent.com/pod-product-compliance
Lightning Source LLC
Chambersburg PA
CBHW080854170526
45158CB00009B/2729